Tasmania: *Small Wonder*

Photographs, text and design by Mike Calder.

Published and distributed by
 Mike Calder Photography
 ph (03) 6227 8649
 fax (03) 6227 9649
 mike@mikecalder.com.au
 www.mikecalder.com.au

1st edition 2015

Calder, Mike
 Tasmania: Small Wonder
 ISBN 978 0 9775492 4 5
 Tasmania - pictorial works
 919.46

Thank you, Jane, for your love and support.

Printed by Everbest.

Tasmania, tucked away in a remote corner of the world, continues to inspire artists, photographers and writers. Isolated when the sea level rose 10,000 years ago, its castaways thrived in an environment of rugged beauty, ice-sculptured peaks and lakes, windswept ocean beaches, secluded tranquil bays, tangled rainforest and buttongrass plains. The Tasmanian Wilderness World Heritage Area covers about 20% of the island and protects one of the last true wilderness regions on Earth.

When the isolation was breached 200 years ago, the newcomers built their own little corner of England, which survives today in the form of grand sandstone buildings, charming villages and rolling farmland. Much of it was too tough to tame and is now protected by World Heritage status, remaining as it has always been; remote wild and untouched.

Tasmania: *Small Wonder* is a photographic essay of this unique and wonderful island. I hope you enjoy it.

Mike.

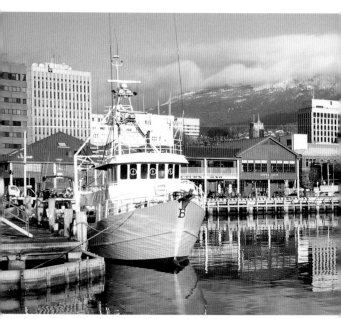

Sullivan's Cove, Hobart with Mt Wellington in the background

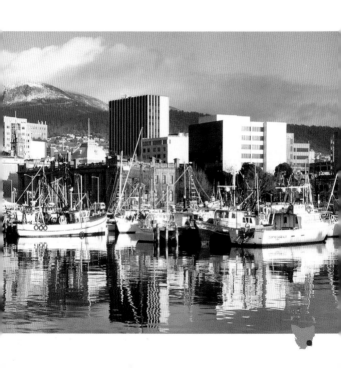

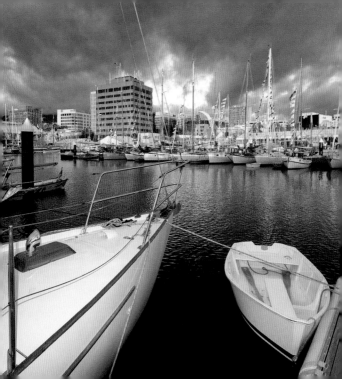

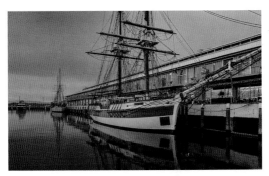

Australia's smallest and most southerly capital city, Hobart (population 200,000) is squeezed into a narrow band along the shore between Mt Wellington and the Derwent River. The Lady Nelson (above) is a replica of the ship in which settlers sailed up the Derwent in 1803 to establish the first European settlement in Tasmania.

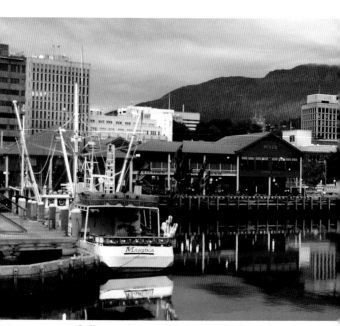

Sullivan's Cove, Hobart and Mt Wellington

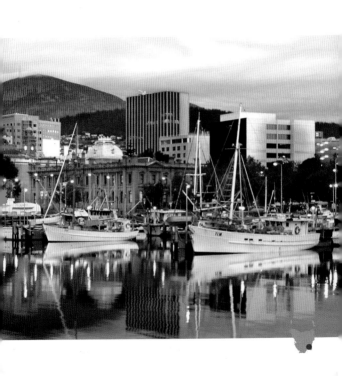

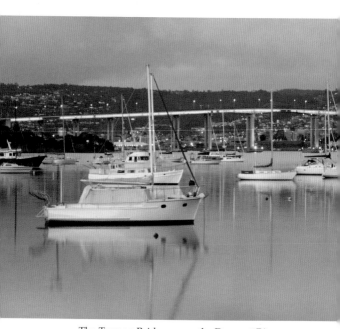

The Tasman Bridge spans the Derwent River

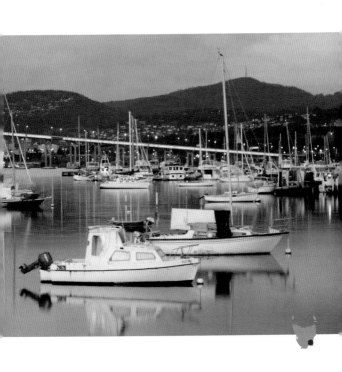

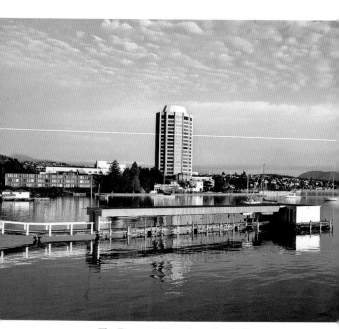

The Derwent River from Sandy Bay

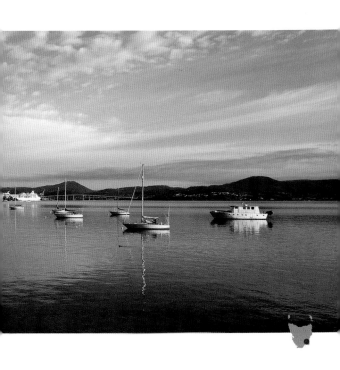

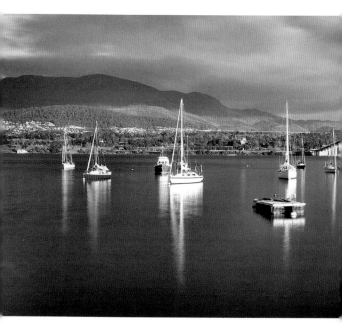

The Derwent River from Montagu Bay

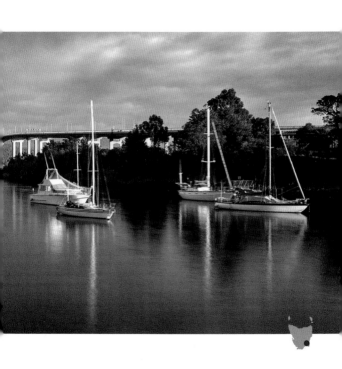

Ocean-racing yachts tie up after the gruelling Sydney-Hobart yacht ra

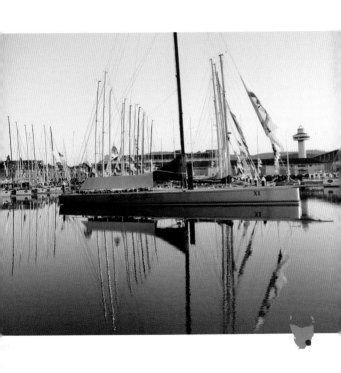

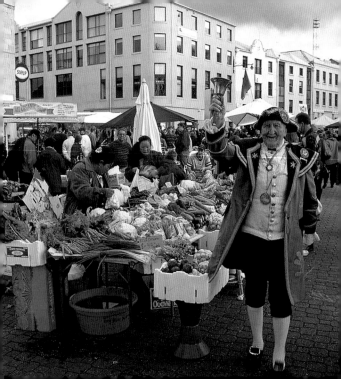

The buildings that line nearby Salamanca Place were the centre of Hobart Town's trade and commerce in the colony's early days. On Saturdays they overlook the bustling Salamanca Market which hosts hundreds of stalls.

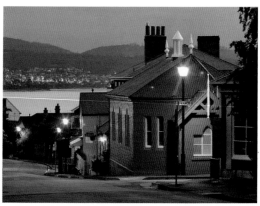

Battery Point was home to the merchants, mariners and labourers of Hobart Town. Here, narrow laneways weave past grand mansions, workmen's tiny cottages and busy boatyards.

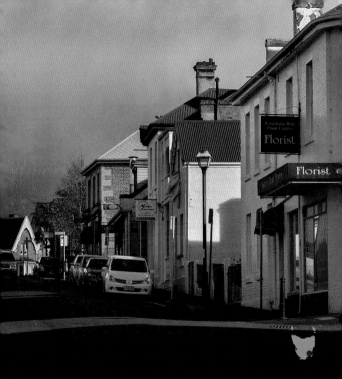

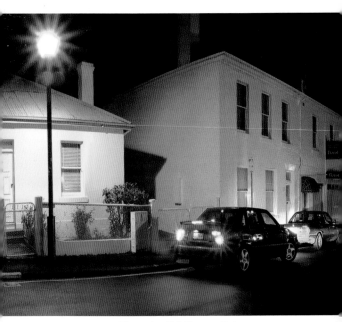

Hampden Rd, Battery Point

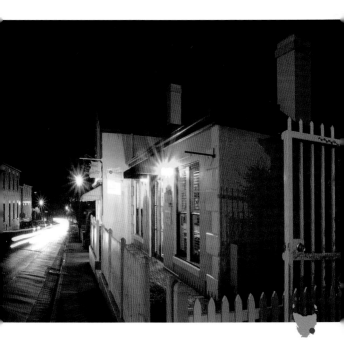

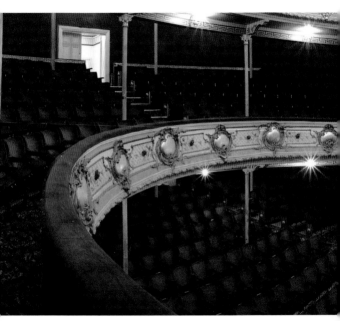

The Theatre Royal was built in 1837 and is Australia's oldest theatre.

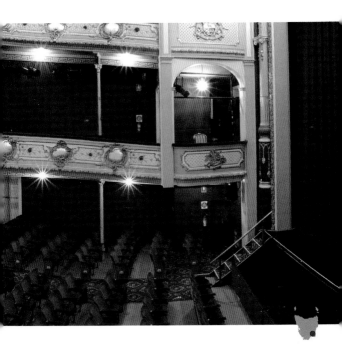

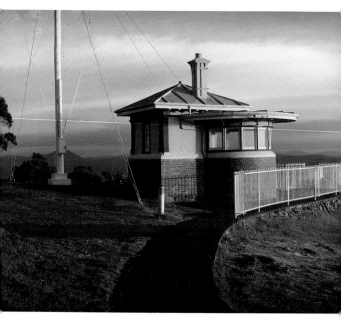

The Mt Nelson Signal Station overlooks Hobart.

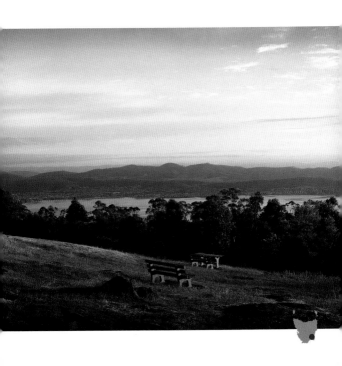

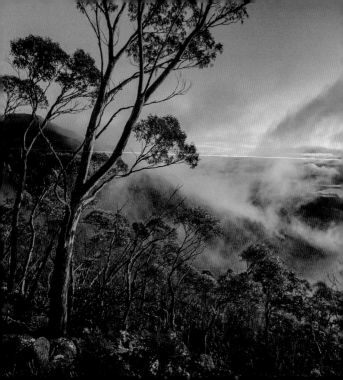

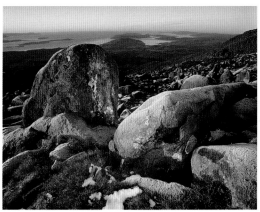

Mt Wellington (1271 m) provides a dramatic backdrop to Hobart and is criss-crossed by many walking and bike trails, providing a wilderness experience close to the city.

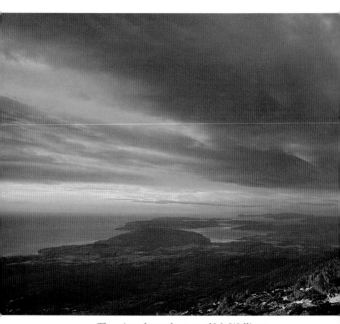

The view from the top of Mt Wellington

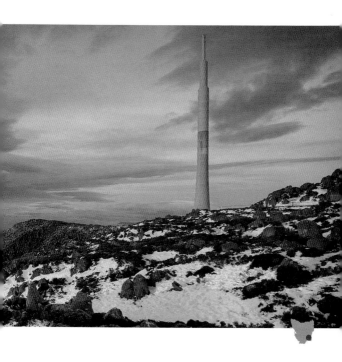

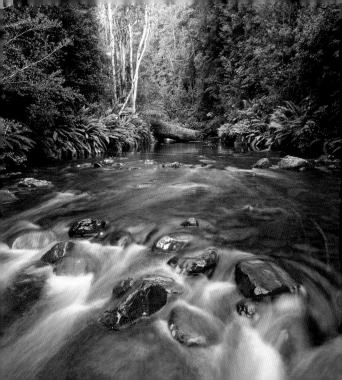

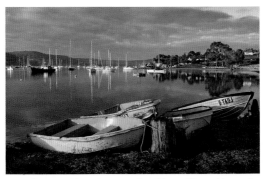

Port Cygnet (above) is on the Huon River. From its origin in the highlands at Lake Pedder, the Huon River flows 170 km through the fertile Huon Valley. The Arve River (left) is one of its tributaries.

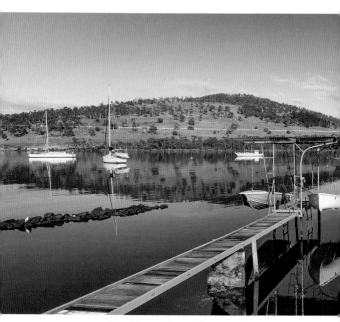

The Huon River at Kermandie

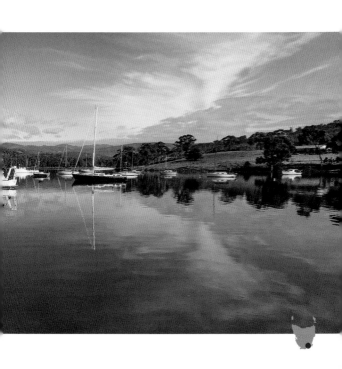

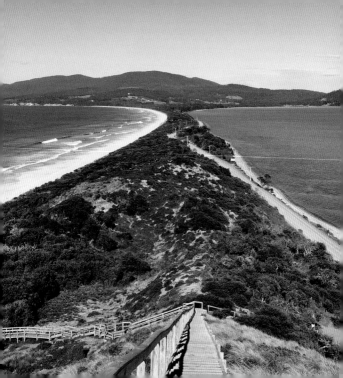

North Bruny and South Bruny are joined by a long, narrow sandy isthmus. Bruny Island is classified by BirdLife International as an *Important bird area* because it supports many endangered species, including the forty-spotted pardalote, the swift parrot and 13 of Tasmania's 14 endemic bird species.

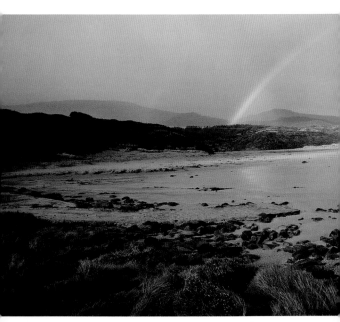

Cloudy Bay, South Bruny Island

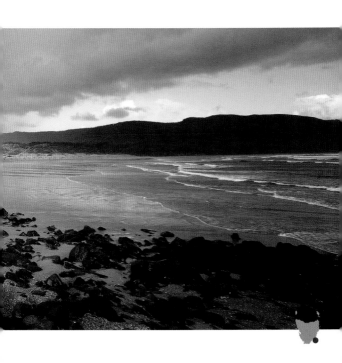

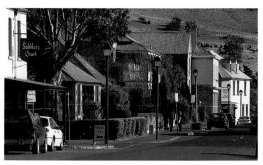

The charming Georgian village of Richmond is one of Australia's most important historic villages. Many of its beautiful old sandstone buildings were built by convict labour and 45 are listed on the National Estate. They include Australia's oldest Catholic church, oldest postal building and oldest gaol. Straddling the Coal River and still in use, Australia's earliest stone arch bridge (right) has been included on the National Heritage List.

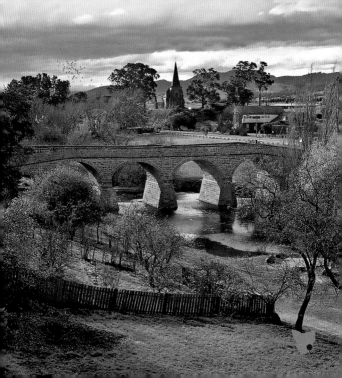

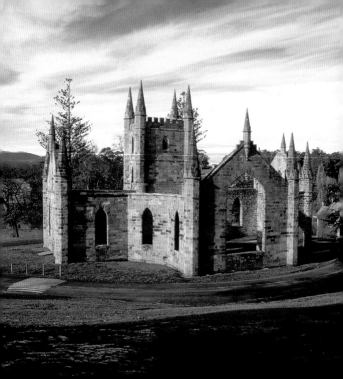

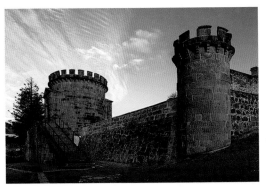

About 12,500 convicts served their time at Port Arthur between 1830 and 1877. They laboured in harsh conditions, isolated from the rest of Tasmania by the narrow Eaglehawk Neck. During this time the penal colony was nearly self-sufficient, producing ships, sawn timber, clothing, boots, bricks and furniture. Convicts built the church in 1836-37, but it was never consecrated as all religions used it.

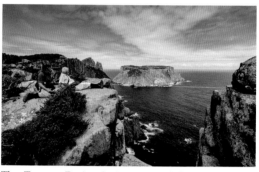

The Tasman Peninsula is separated from the rest of Tasmania by the narrow Eaglehawk Neck. The peninsula is known for its coastline and high coastal cliffs, rising 300 m above the sea at Cape Pillar. The Tessellated Pavement (right) looks like it was laid by a bricklayer.

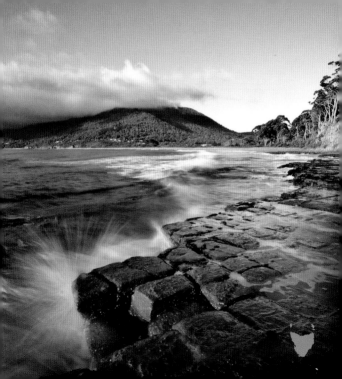

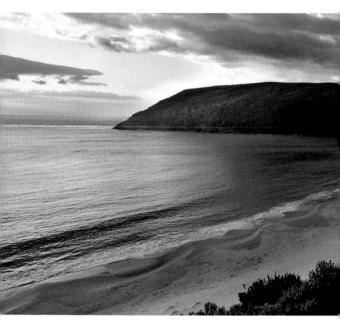

Crescent Bay, Tasman Peninsula

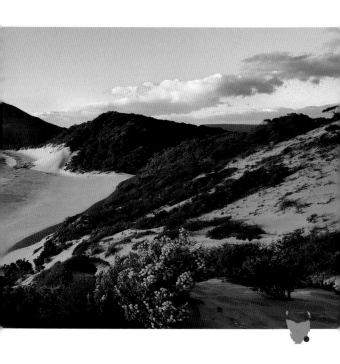

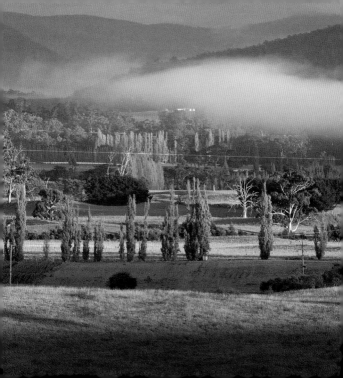

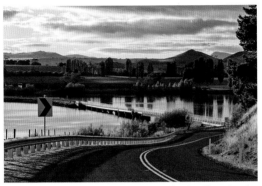

The Derwent River flows from Lake St Clair in the Central Highlands 187 km to New Norfolk, where the estuary portion extends beyond Hobart a further 52 km out to sea. New Norfolk (overleaf) is a historic and picturesque town of 5000 people.

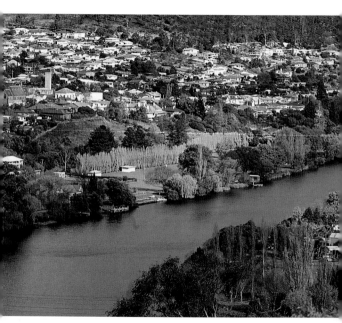

The Derwent River at New Folk

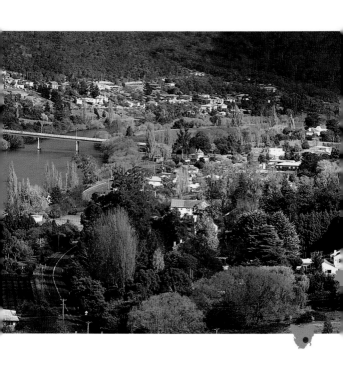

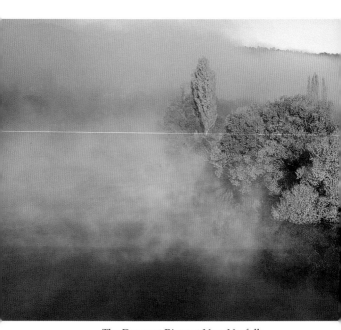

The Derwent River at New Norfolk

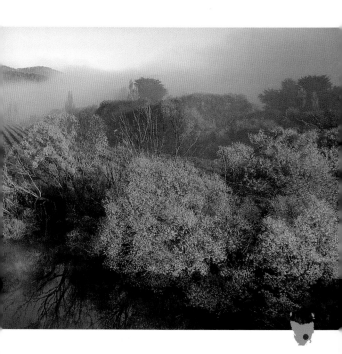

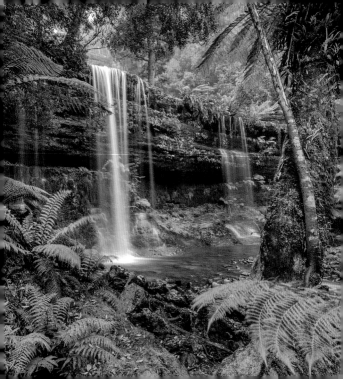

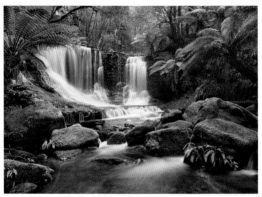

About an hour's drive northwest of Hobart is the Mt Field National Park, where an easy walk leads to Russell Falls (left) and Horseshoe Falls (above).

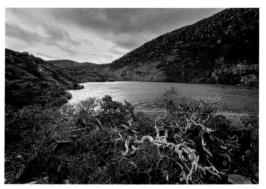

Higher up in the Mt Field National Park is an area of sub-alpine wilderness and glacially-formed lakes. At Lake Dobson (right), an ancient pencil pine greets the morning sun. These trees grow slowly and can live up to 1300 years. Nothofagus gunnii shrubs surround a tarn on the Tarn Shelf (above); these are the only native deciduous trees in Australia.

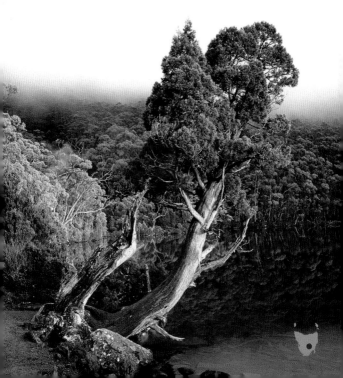

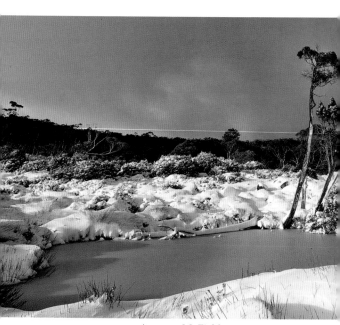

A tarn at Mt Field

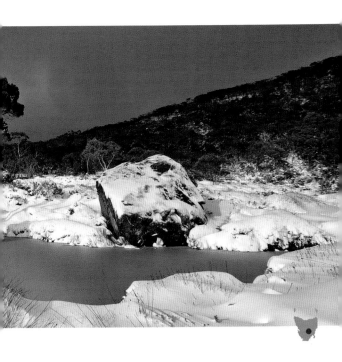

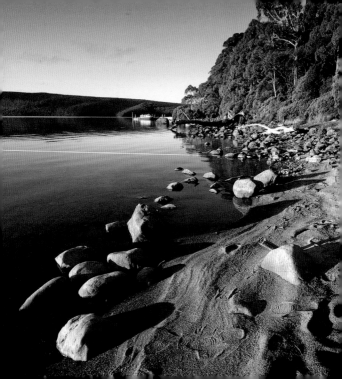

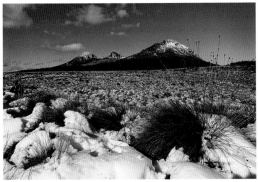

Over the last 2 million years, glaciers have gouged out Lake St Clair (left), headwaters of the Derwent River and Australia's deepest natural lake at 200 m. Nearby is Mt King William (above).

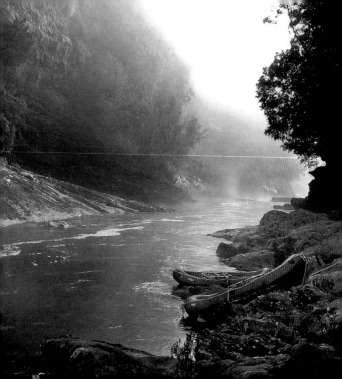

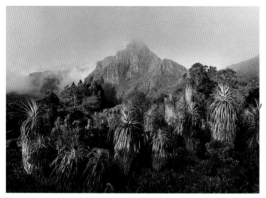

The Tasmanian Wilderness World Heritage Area covers about 20% of the area of Tasmania and encompasses most of the southwest. It contains some of the wildest and remotest areas of the world. The Franklin River (left) and Mt Anne (above) are features of the world heritage area.

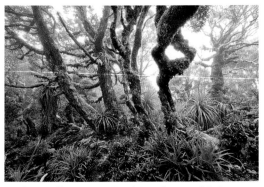

King Billy Pines and cushion plants on Mt Anne

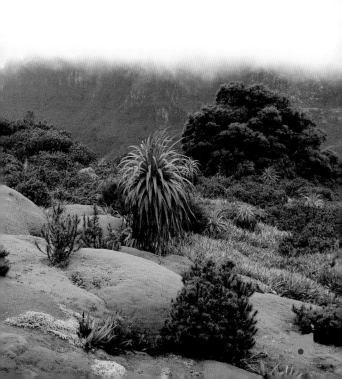

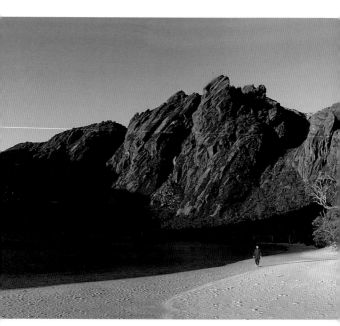

Lake Rhona, southwest Tasmania

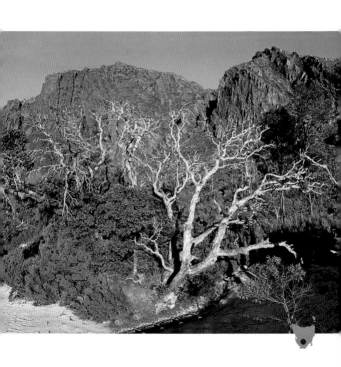

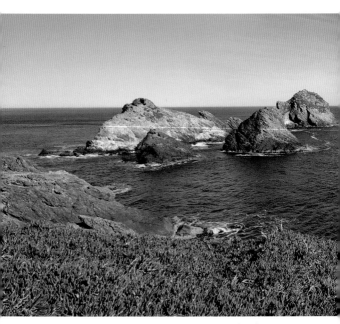

The Pinnacles, Maatsuyker Island

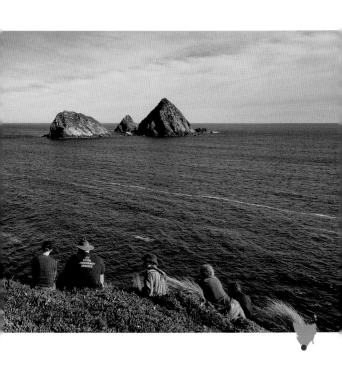

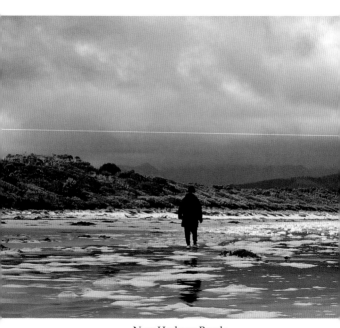

New Harbour Beach

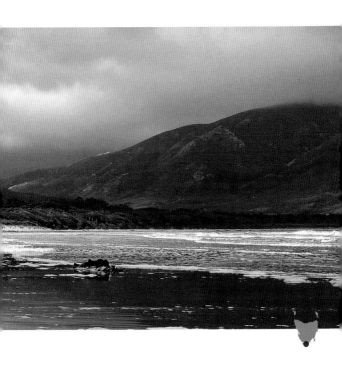

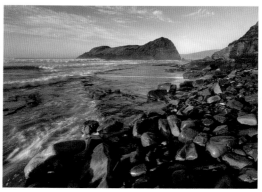

Lion Rock and Noyhener Beach, southwest Tasmania

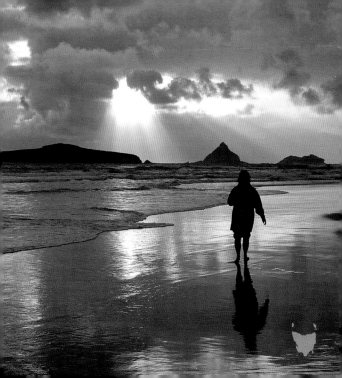

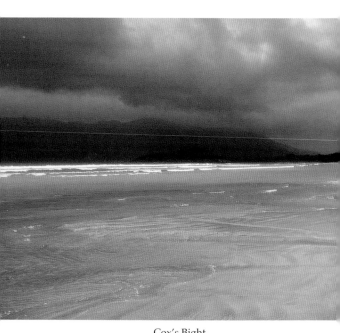

Cox's Bight

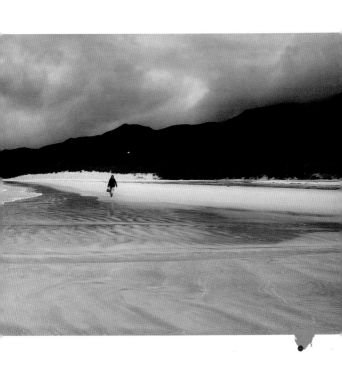

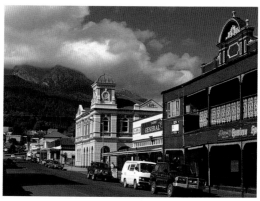

Minerals and gold were discovered in the Queenstown area in the 1880s, and the town grew rapidly when copper mining commenced in 1893. Trees growing on the surrounding hills were cut down to fuel smelters and when the topsoil was washed away by the area's heavy rainfall, the bare colourful rocks and lunar landscape we see today emerged.

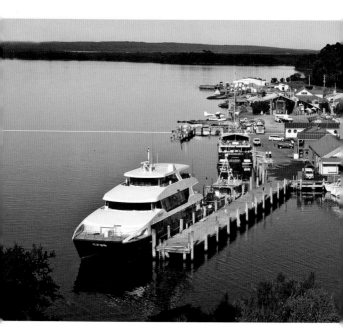

Strahan

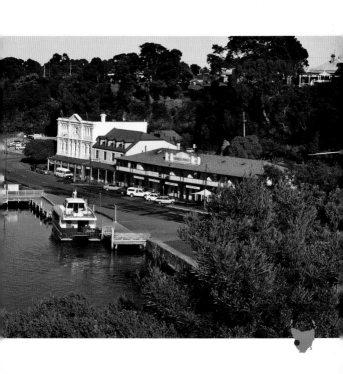

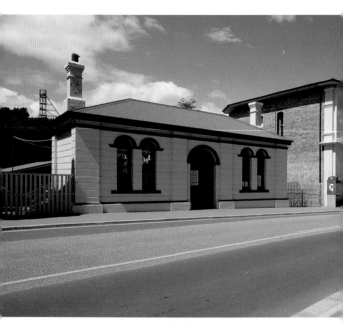

Zeehan

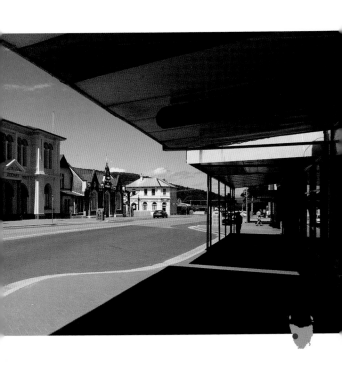

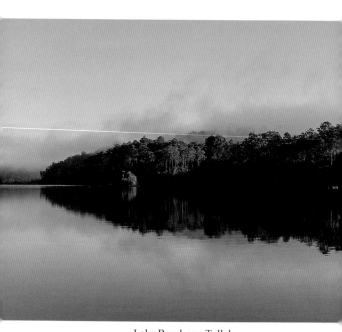

Lake Rosebery, Tullah

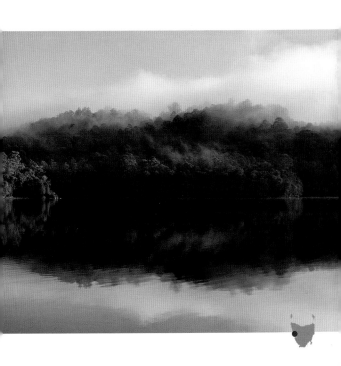

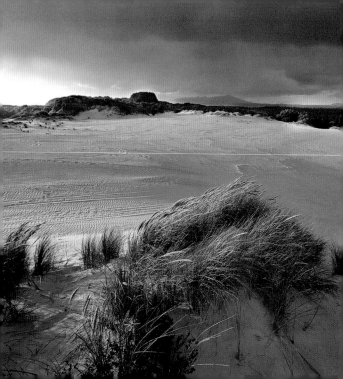

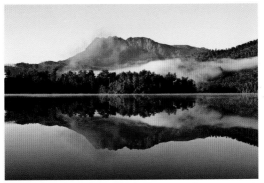

Mt Murchison and the Henty Dunes on the west coast

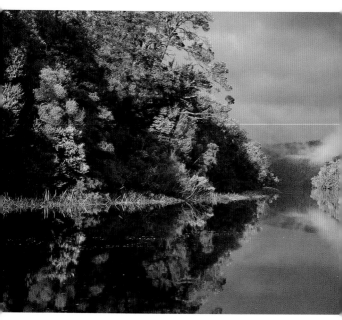

The Pieman River

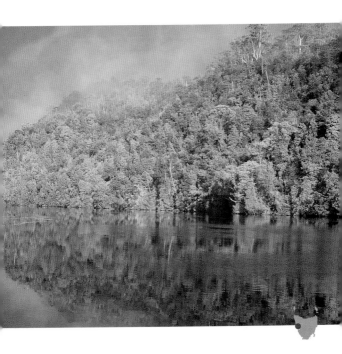

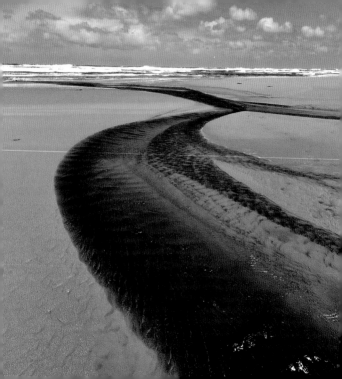

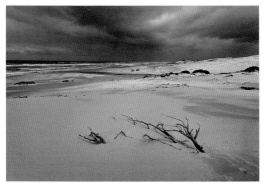

The Tarkine Coast at Interview River

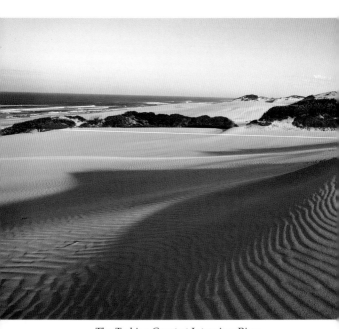

The Tarkine Coast at Interview River

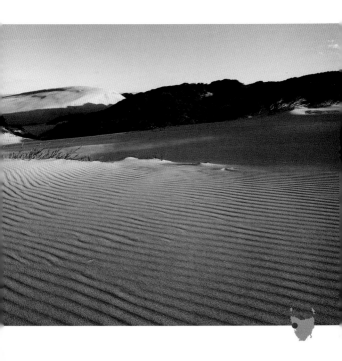

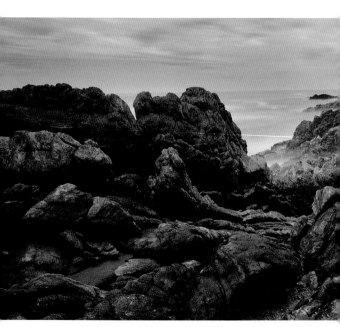

The Tarkine Coast north of the Pieman River

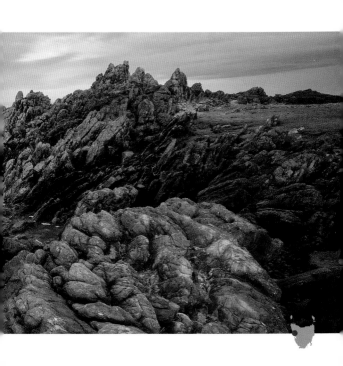

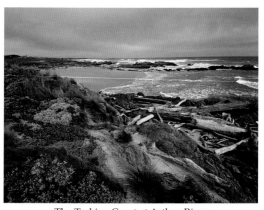

The Tarkine Coast at Arthur River

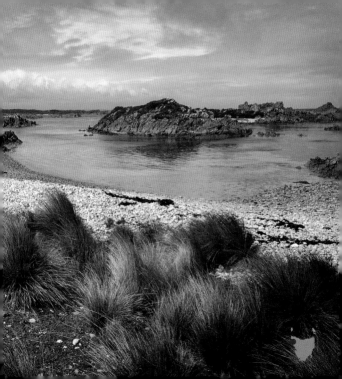

Windswept King Island stands guard over the western end of Bass Strait, about half way between Tasmania and Victoria and in the path of the Roaring Forties. Over 50 ships have come to grief on the 145 km of coastline. It is renowned for its beef, dairy and seafood.

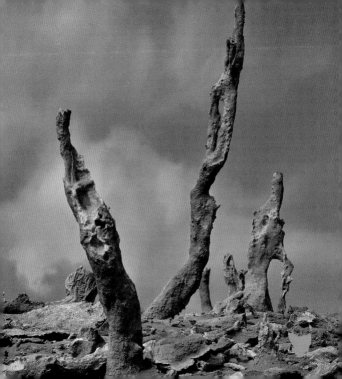

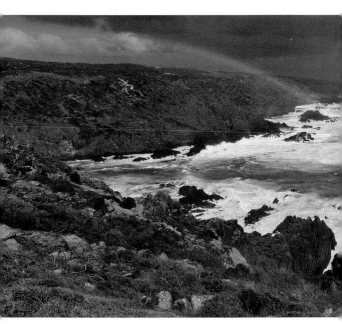

Seal Rocks, King Island

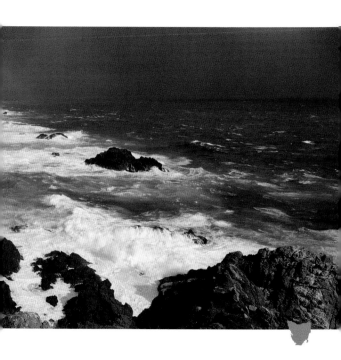

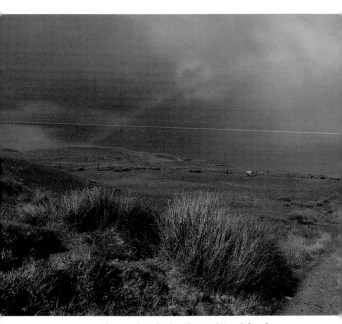

The road to Stokes Point, King Island

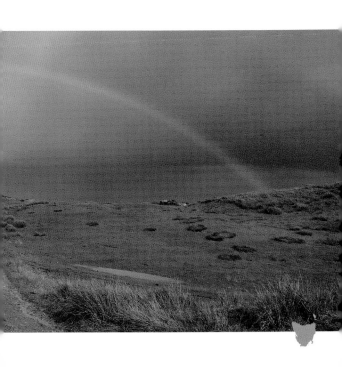

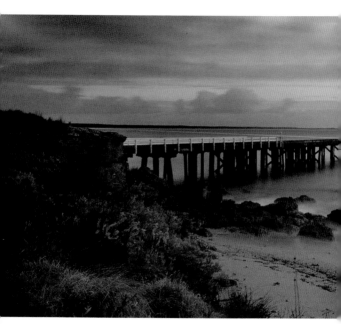
Naracoopa Jetty, King Island

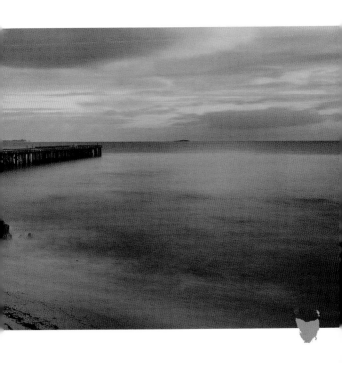

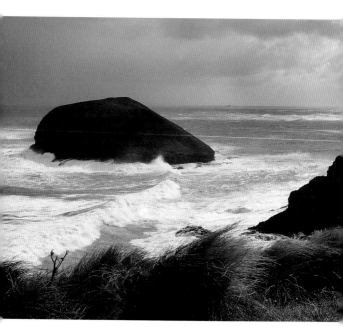

Cape Grim

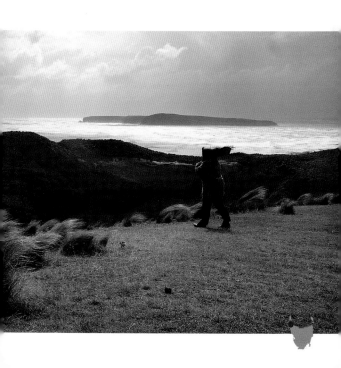

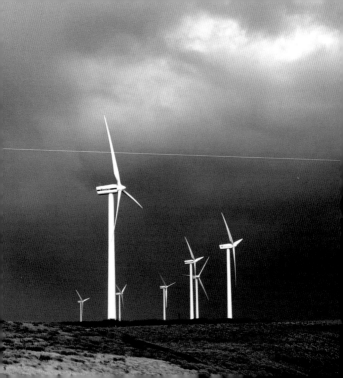

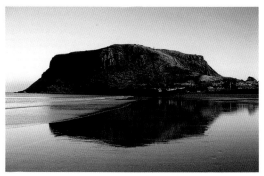

At windswept Cape Grim, the Woolnorth Wind Farm (left) harnesses the wind to generate power for Tasmania's grid. Each of the 37 towers is 60 m high, has a blade diameter of 66 m and operates most efficiently in wind speeds between 55 and 90 km per hour, making this farm ideally suited to conditions at Cape Grim. The Nut (above) overlooks the historic township of Stanley.

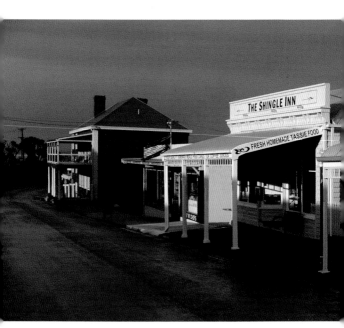

Stanley

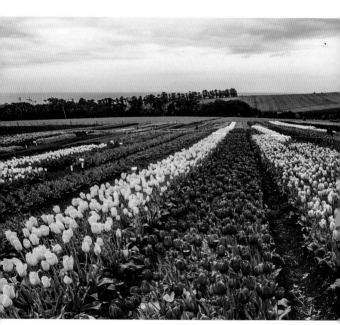
Tulips at Table Cape, Wynyard

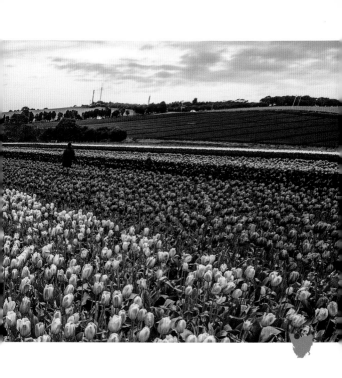

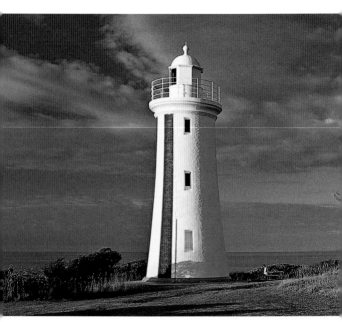

Bluff Lighthouse, Devonport

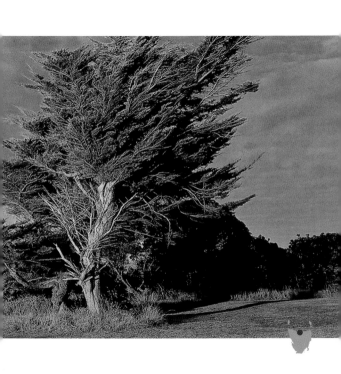

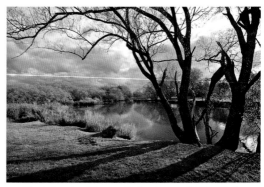

The Meander River at Deloraine and Liffey Falls

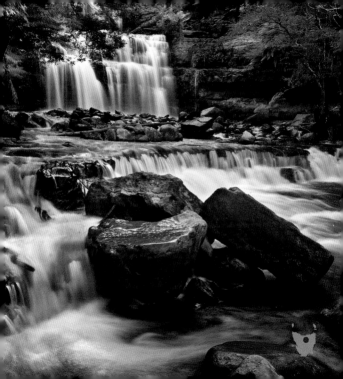

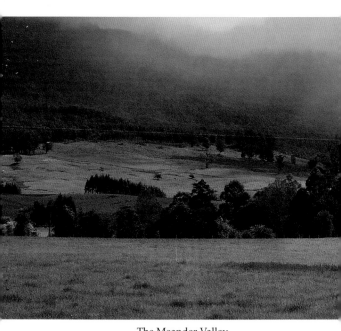

The Meander Valley

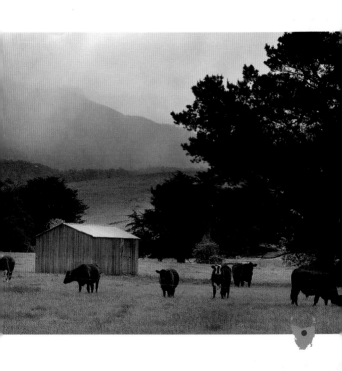

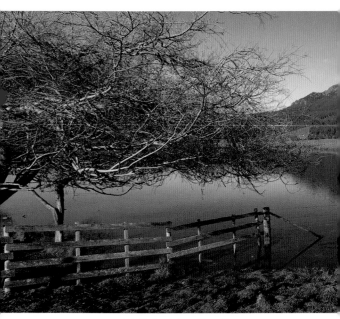

Mt Roland from Paradise

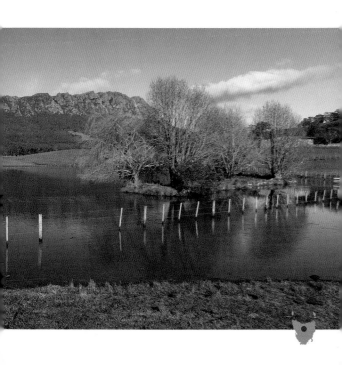

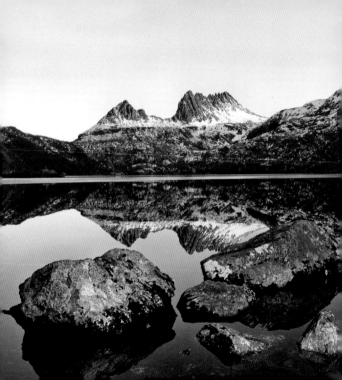

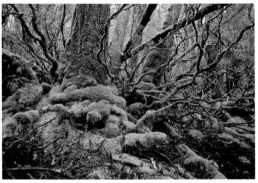

Like many of the dolerite-capped mountains of Tasmania, Cradle Mountain's jagged profile was sculpted when glaciers gouged it in the last ice age, about 10,000 years ago. On 4 January 1910, Gustav Weindorfer drew breath on the 1545 m summit and proclaimed, "This must be a national park for the people for all time. It is magnificent, and people must know about it and enjoy it."

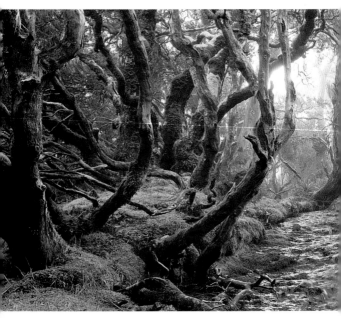

Myrtle Forest at Waterfall Valley, Cradle Mountain Lake St Clair National Park

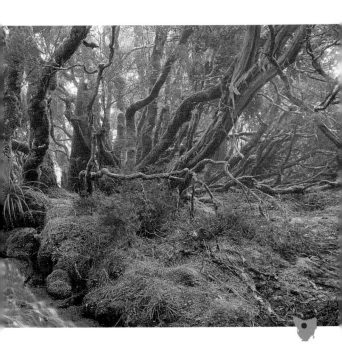

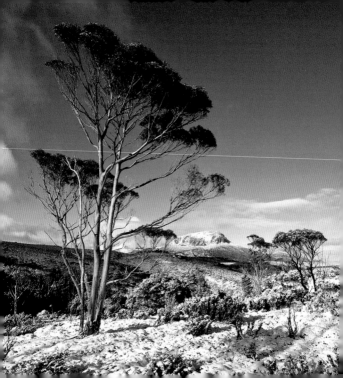

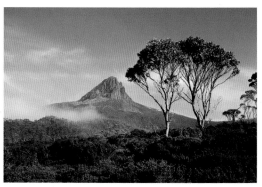

Mt Pelion West (left) and Barn Bluff (above)

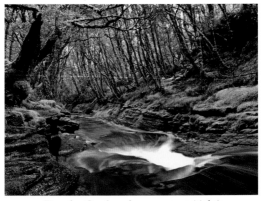

Douglas Creek and a snow gum (right)

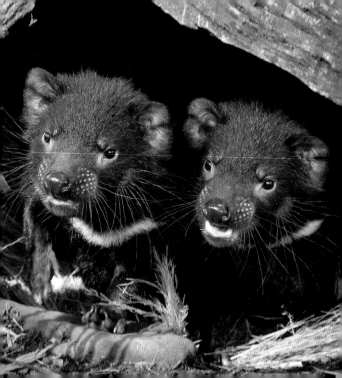

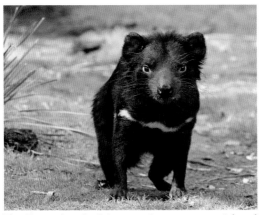

The Tasmanian devil is a carnivorous marsupial and usually scavenges for its meals. However it can hunt, its powerful jaws enabling it to completely devour all of its prey - meat, bones and fur. The young are born in April, and the mother carries them in her backward-opening pouch for four months. By December, the young are living independently.

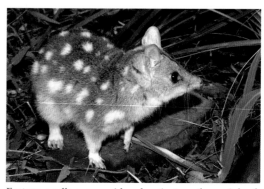

Eastern quolls are considered extinct on the mainland, but are widespread and common in Tasmania. They are impressive hunters, taking small mammals such as rabbits, mice and rats; but mainly they eat insects as well as carrion and some fruits. The young develop in a pouch for about 10 weeks.

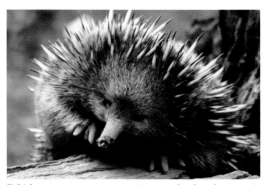

Echidnas are monotremes (mammals that lay eggs). There are only two monotremes in the world – platypuses and echidnas. In many ways they are like reptiles, they lay eggs, have legs that extend outward then downward and have and a lower body temperature than other mammals. The females lay a single egg directly into a small backward-facing pouch. They eat mainly ants and termites.

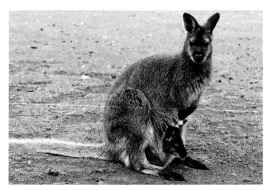

There are five species of macropods in Tasmania: the Forester kangaroo, Bennetts wallaby, pademelon, bettong and potoroo. Members of this group usually move around by hopping. They give birth to young which have developed little past the embryo stage. The young continue to develop within the female's pouch.

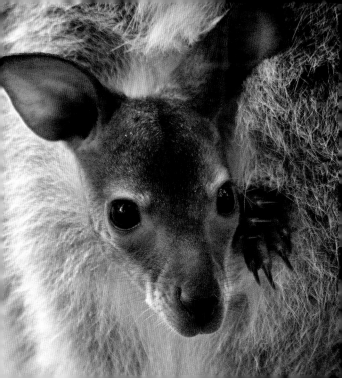

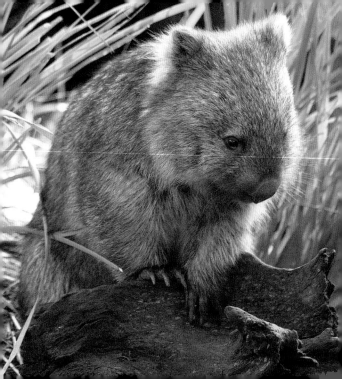

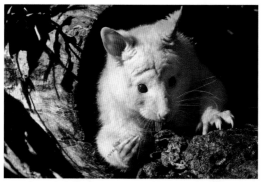

Wombats (left) have short legs, large paws and long, strong claws which are used in the excavation of burrows, which can be up to 20 m long and 2 m below the ground. Being marsupials, female wombats have a pouch which in their case opens backward to prevent dirt and debris entering while burrowing. Brushtail possums (above) are common marsupials in Tasmania; they live in trees and are plant-eaters. Golden possums like this one are a genetic mutation.

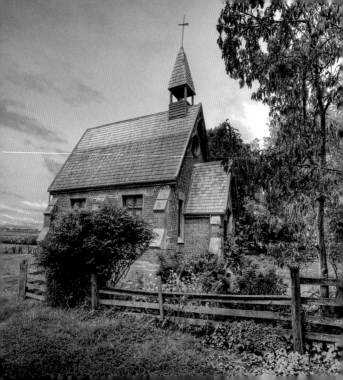

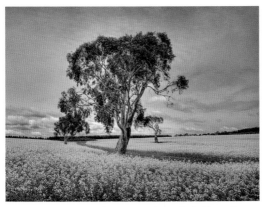

The old chapel at Brickendon and canola fields at Cressy

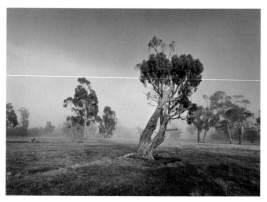

Tasmania's Midlands

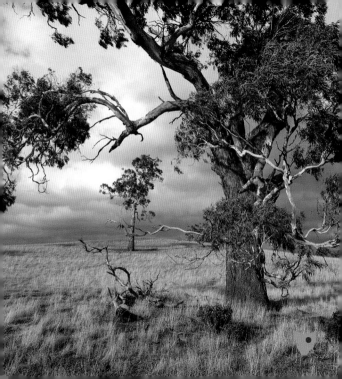

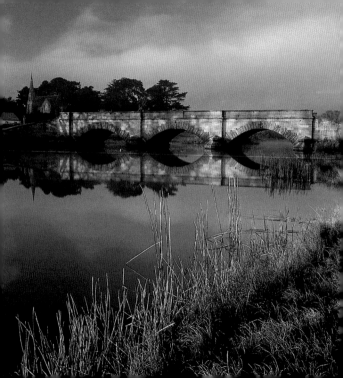

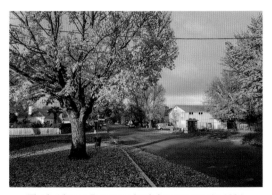

The bridge at Ross was built by convicts in 1836.

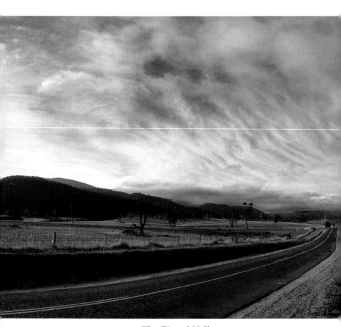

The Fingal Valley

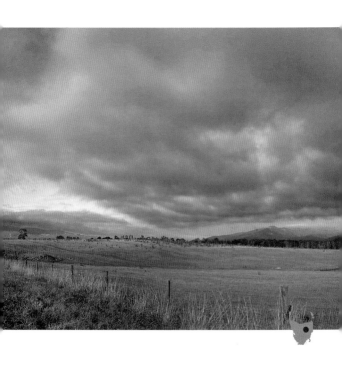

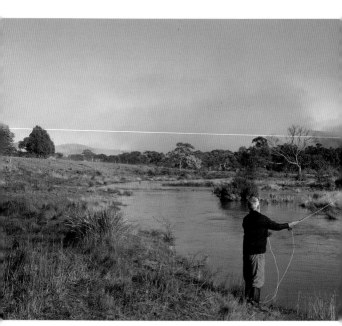

St Paul's River, Fingal Valley

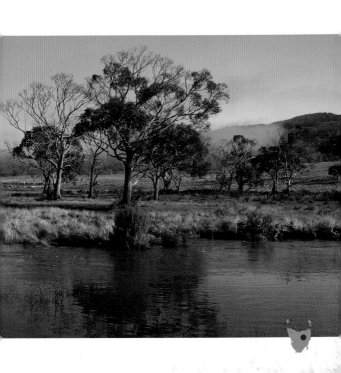

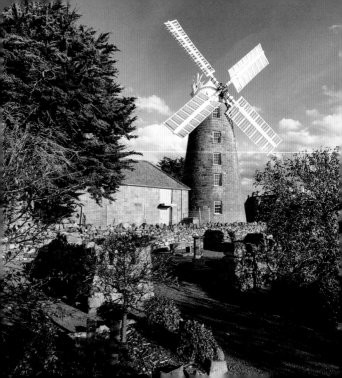

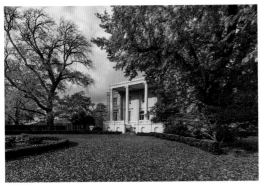

Callington Mill, Oatlands (left) and Clarendon House

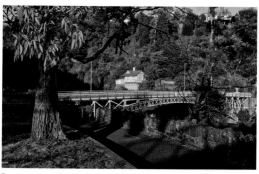

Launceston (population 100,000) is Tasmania's second-largest and Australia's third-oldest city. Situated where the North and South Esk Rivers join to form the Tamar River, it is an attractive city with beautiful parks and gardens. It has managed to retain much of its heritage and architecture and has the largest collection of 19th century buildings in the country.

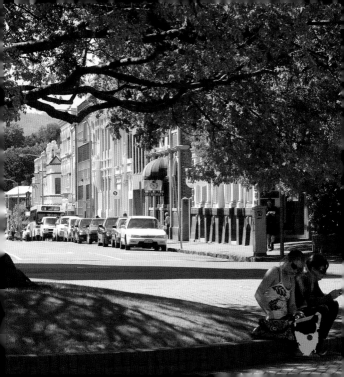

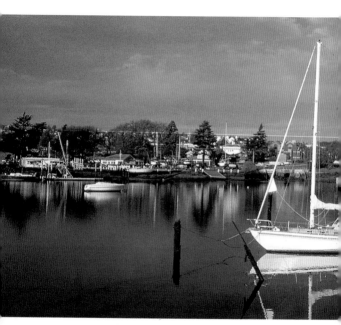

The Tamar River at Launceston

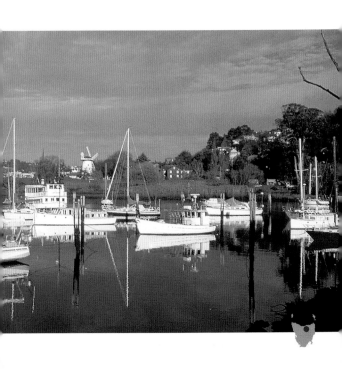

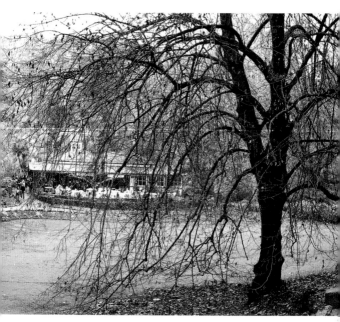

Cataract Gorge Reserve, Launceston

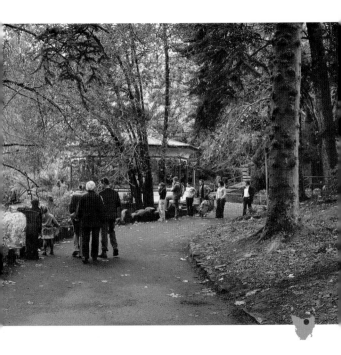

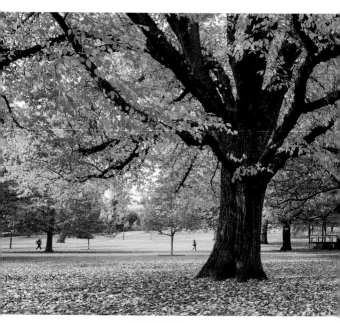

City Park, Launceston

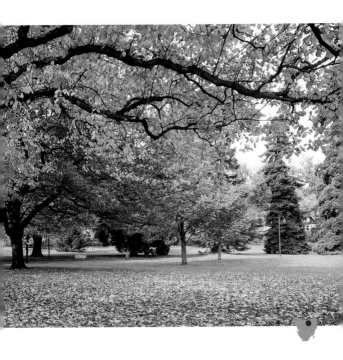

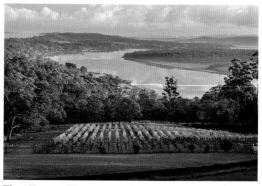

The Tamar River runs from Launceston through Tasmania's premier wine district on the way to its mouth at Low Head.

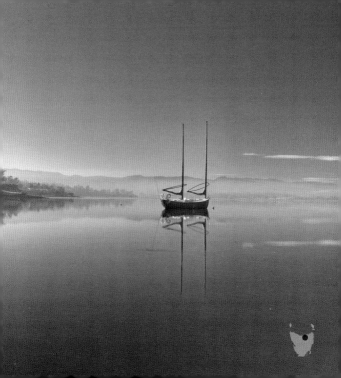

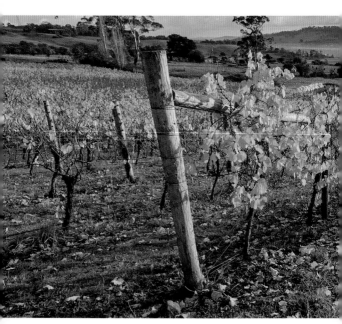

A Tamar Valley vineyard

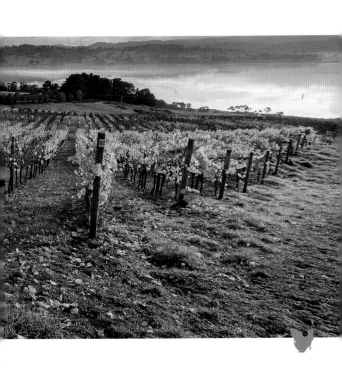

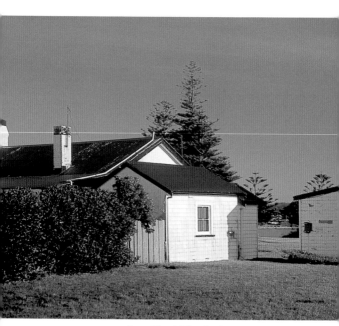

Low Head Pilot Station

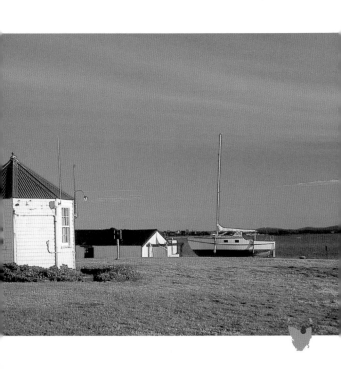

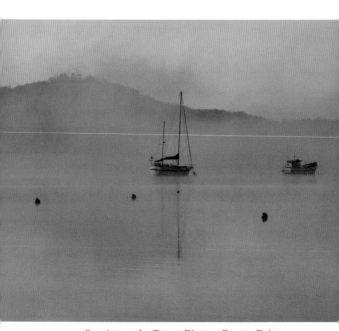
Sunrise on the Tamar River at Beauty Point

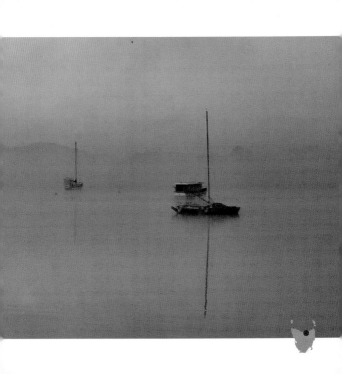

In early January, the five-week harvesting operation at Bridestowe Lavender Farm packs the flowers into bins ready for distillation on site. Most of the crop is distilled and the rest is sun-dried for the dried flower industry. It takes 10 tonnes of flowers to produce 1 tonne of dried flowers.

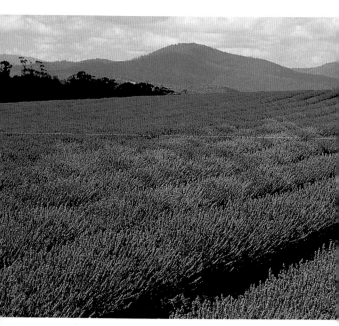

Bridestowe Lavender Farm

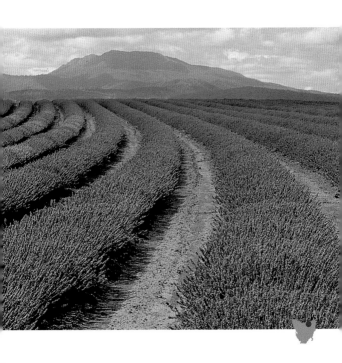

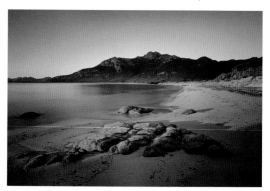

Beautiful Flinders Island is the main island of the Furneaux Group, a collection of 52 islands that stretch across Bass Strait between northeast Tasmania and mainland Australia. It's 62 km long by 37 km wide and about a third of the island is mountainous and rugged, with ridges of granite running its length. At 756 m, Mt Strzelecki (pictured) is the island's highest peak.

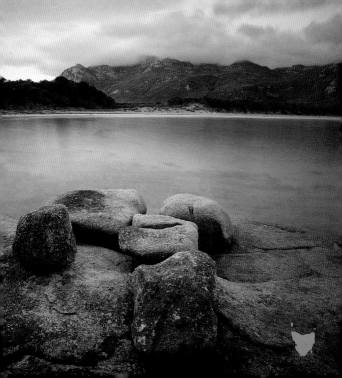

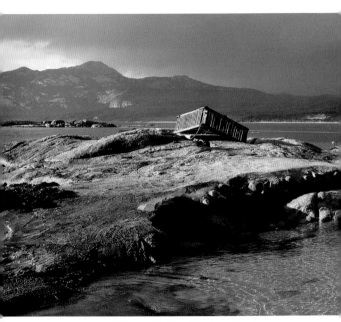

Killiecrankie Bay, Flinders Island

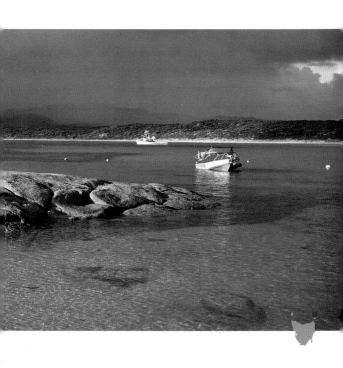

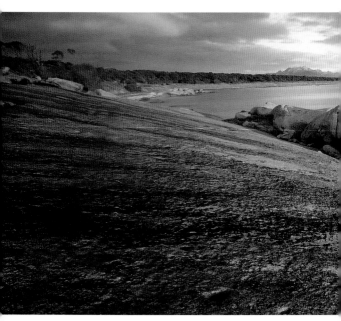

Blue Rocks, Flinders Island

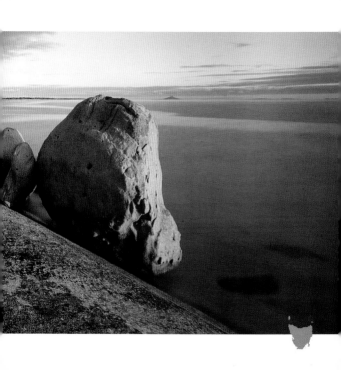

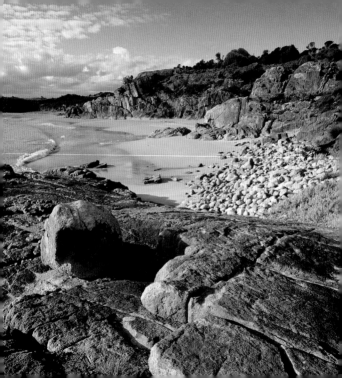

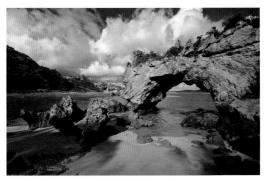

Stackys Bite, Flinders Island

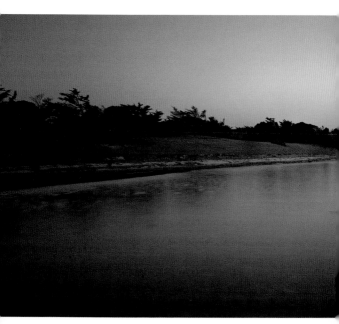

Mt Strzelecki from Whitemark, Flinders Island

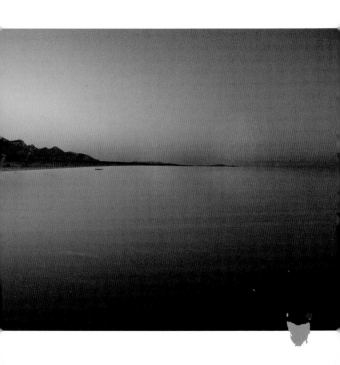

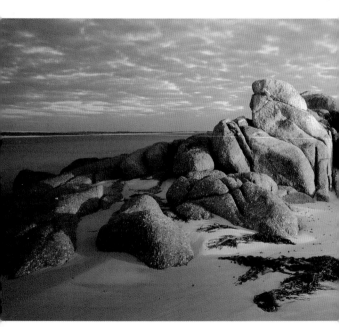

Stumpy Bay

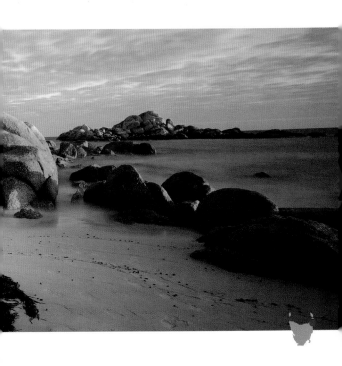

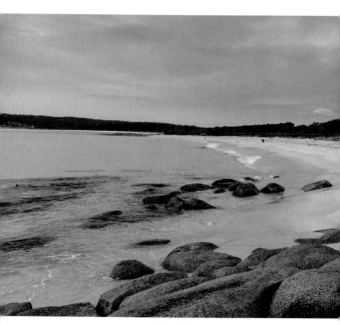

Bay of Fires

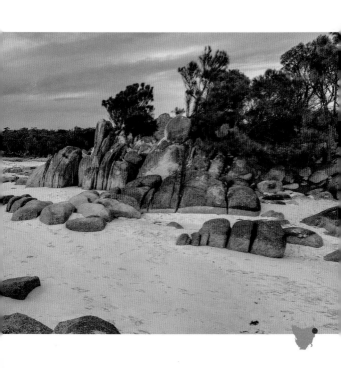

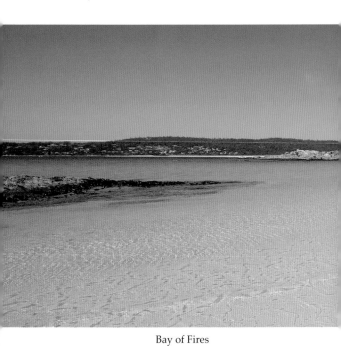

Bay of Fires

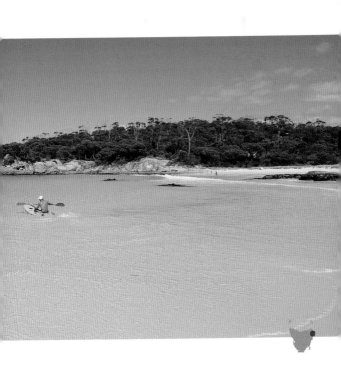

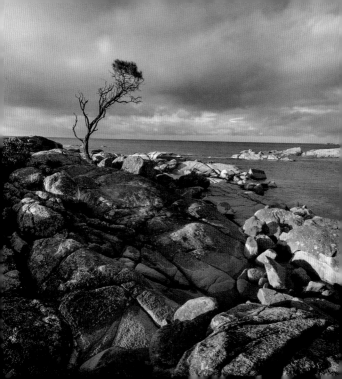

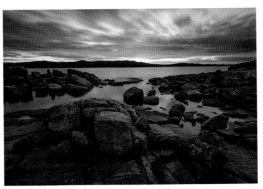

Binalong Bay

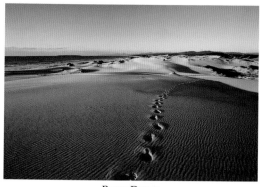

Peron Dunes

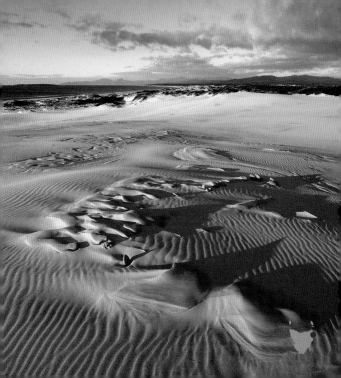

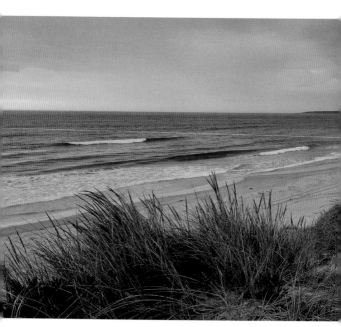

Peron Dunes

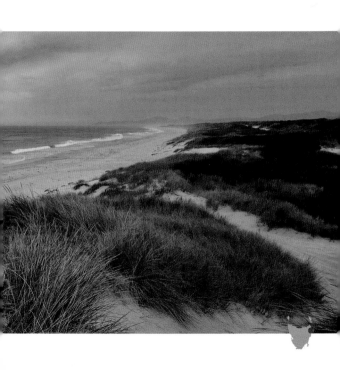

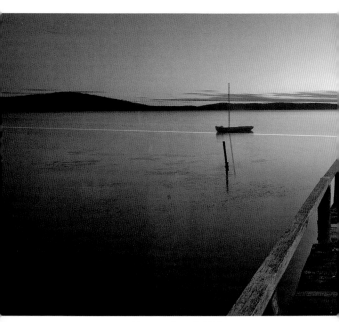

Georges Bay, St Helens

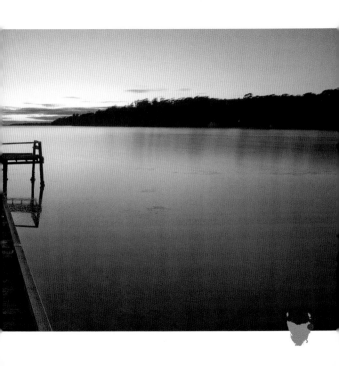

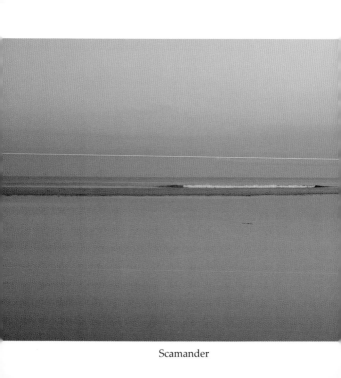

Scamander

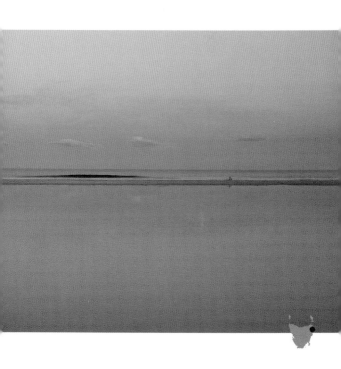

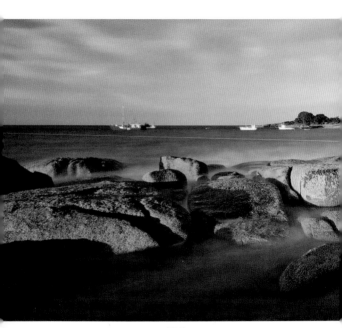

Bicheno

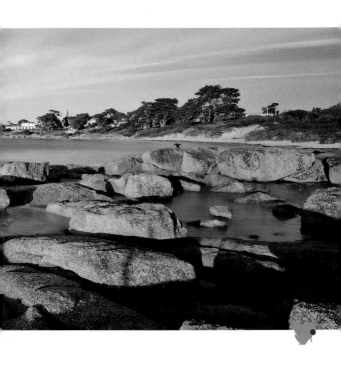

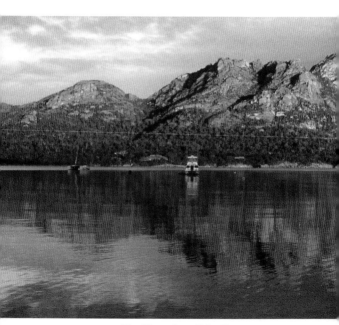

The Hazards at Coles Bay

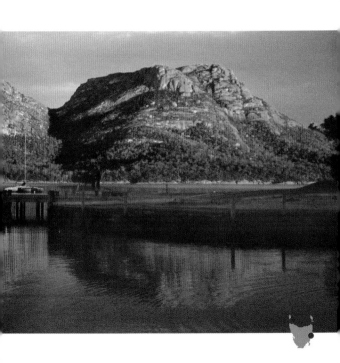

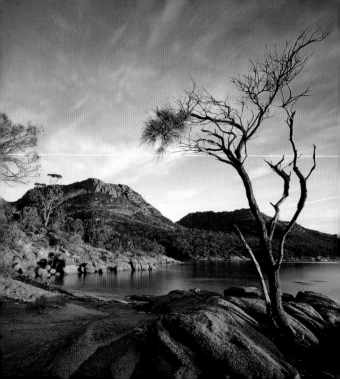

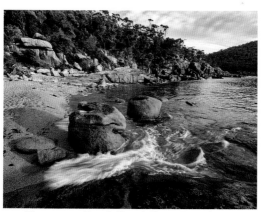

Honeymoon Bay (left) and Sleepy Bay (above)

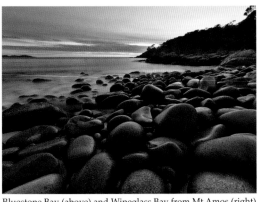

Bluestone Bay (above) and Wineglass Bay from Mt Amos (right)

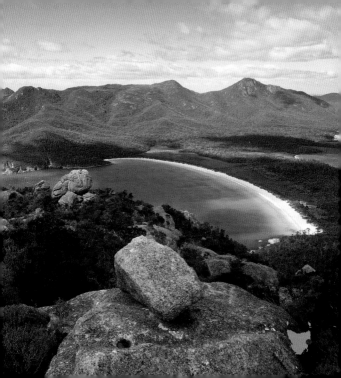

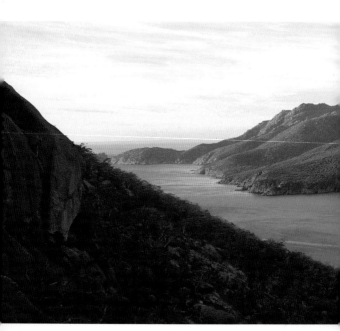

Wineglass Bay

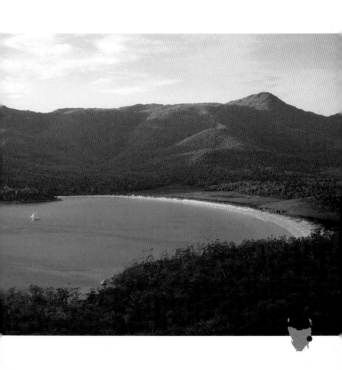

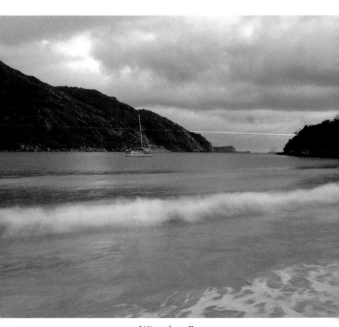

Wineglass Bay

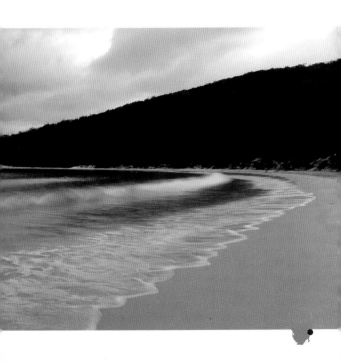

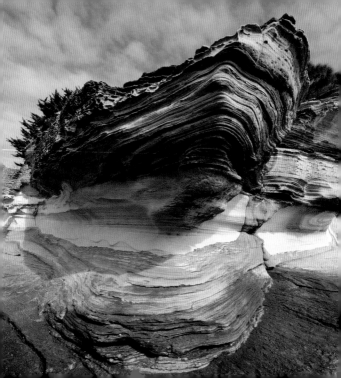

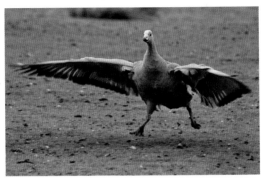

Maria Island has a colourful history, and its 14 convict buildings and ruins have remained relatively unchanged since the convict era. In the 1880s, the Italian entrepreneur Diego Bernacchi set up island enterprises including silk and wine production and a cement factory, all of which subsequently failed. The entire island is a now a national park, part of which is a marine area. Cape Barren geese (above) are common on the island.

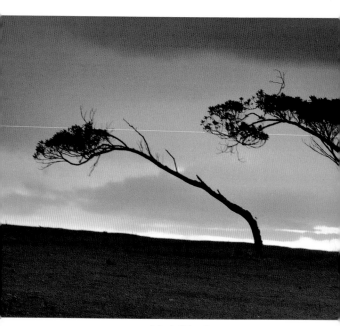

Maria Island

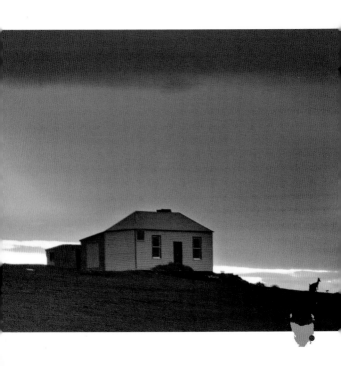

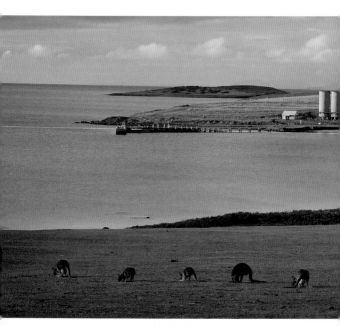

Maria Island

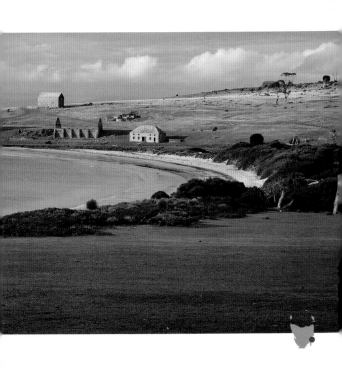

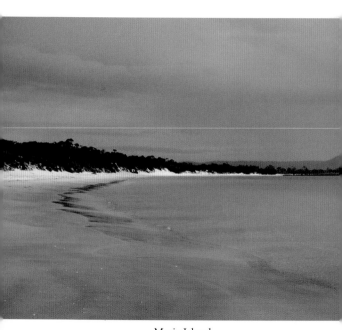

Maria Island

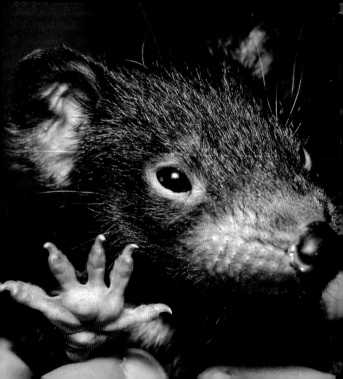

Thank you for reading

Photographs in this book can be found at
www.mikecalder.com.au